Are Those Animals REAL?

How Museums Prepare Wildlife Exhibits

REVISED AND UPDATED EDITION

JUDY CUTCHINS
and GINNY JOHNSTON

Morrow Junior Books • New York

Acknowledgments

The authors would like to give special thanks to the following extraordinarily talented experts for their help in the development of *Are Those Animals REAL?*: Mozelle Funderburk, molding and casting expert at Fernbank Science Center in Atlanta, for her expertise and help with photographs; Ed Thompson at Fernbank Science Center; Dana Stanford at Fernbank Museum of Natural History; Bud and Jackie Jones, their family, and the entire staff at Bud Jones Taxidermy Studio, Tallapoosa, Georgia, for their assistance in the area of taxidermy; Bill Munns, the very creative California artist/sculptor who generously contributed both photographs and details about the production of the dimetrodon, orangutan, and giant tortoise. Without the assistance of the people named above, *Are Those Animals REAL?* would not have been possible.

Photo Credits

Permission for the following photographs is gratefully acknowledged: William H. Munns, pages 6, 24, 26, 27, 28, 30, 31, 32, 33, and 34; Chase Studio, Inc., page 7; Fernbank Science Center, page 23; Fernbank Museum of Natural History, page 29. The photographs on pages 4, 5, 8, 10, 11, 12, 14, 15, 16, 17, 18, 19, 20, 21, 22, 35, 36, 37, and 38 are by Judy Cutchins.

The text type is 14-point Sabon.

Library of Congress Cataloging-in-Publication Data
Cutchins, Judy. Are those animals real?: how museums prepare wildlife exhibits/Judy Cutchins and Ginny Johnston. —Rev. and updated ed. p. cm. Includes index.
ISBN 0-688-12854-8 (trade)—ISBN 0-688-12855-6 (library)
1. Taxidermy—Juvenile literature. 2. Zoological models—Juvenile literature. 3. Zoological specimens—Collection and preservation—Juvenile literature. 4. Museum techniques—Juvenile literature.
[1. Taxidermy. 2. Museum techniques. 3. Zoological models.] I. Johnston, Ginny. II. Title.
QL63.C88 1995 579'.4—dc20 94-23891 CIP AC

Contents

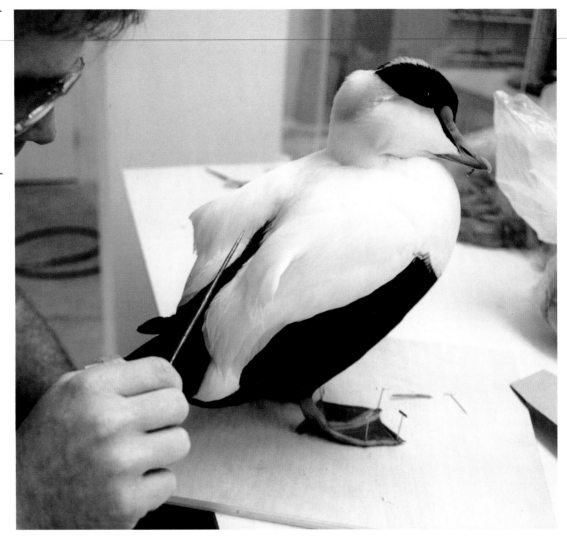

A museum artist smooths the feathers of an eider duck that died in a nature preserve and became a specimen for exhibit.

Wildlife for Exhibit

How can an animal look so real but not be alive? That's a question most people ask when they see wildlife on exhibit in museums. Museum artists use a fascinating variety of techniques to make animals look real and alive for exhibits. In fact, many of the animals were alive at one time. They were acquired by the museum after they died. The animals may have died in captivity or in the wild. They may also have been killed illegally. If the hunter is caught, the animal is taken, and the hunter is fined or arrested. The dead animal may be given to a museum for an exhibit if the museum has the proper permits from the government.

Museums use different methods of preparing wildlife for exhibits, depending on the particular animal. For example, if a museum receives a dead mammal or bird, the staff removes its furry or feathered skin and treats it so that it will last for many years. The preserved skin is then fitted over an artificial body form. (This process is

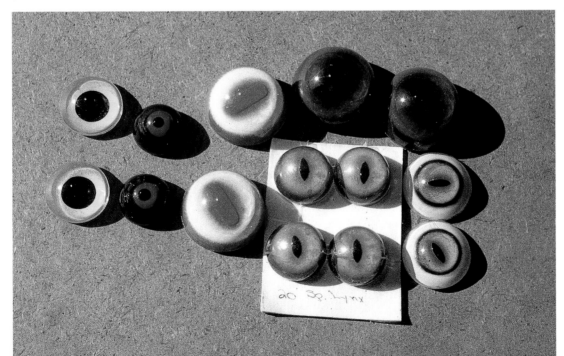

Real eyes cannot be used in taxidermy because they would decay and shrivel. Taxidermists purchase glass eyes from a wildlife art company.

5

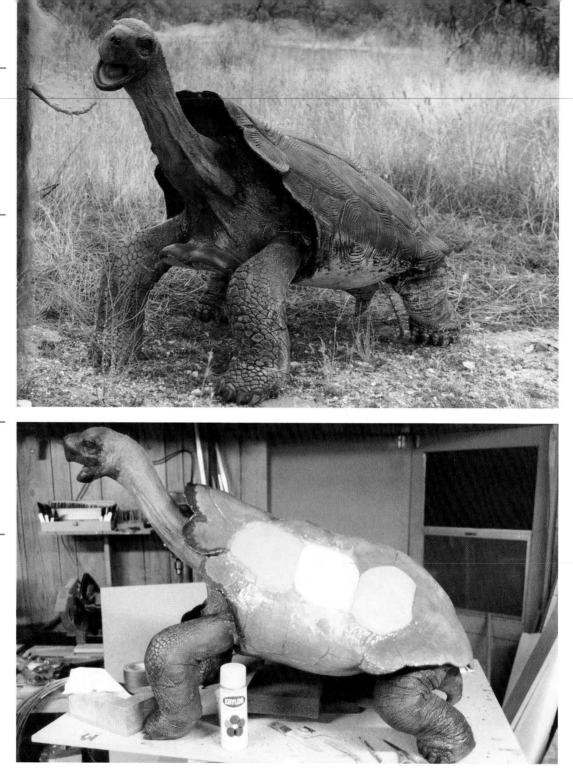

This giant desert tortoise appears to munch hungrily on a cactus. Actually, the tortoise is a totally artificial re-creation.

Foam and wire are hidden beneath the realistically painted shell and skin.

6

called taxidermy.) Glass eyes in the same size and color as the animal's real eyes are added. They help make a taxidermy specimen look alive again.

Some of the animals in exhibits were never alive. They are lifelike models made from molds of dead animals. In this case, an artist makes a mold of the animal by pressing its body into wet plaster. When the plaster hardens, the animal is removed and its imprint is left. Liquid rubber or plastic is poured into this plaster mold. When it dries and hardens, the plastic makes an exact copy, called a cast, of the animal. Then the cast is painted to look like the real animal.

Sometimes a museum wants to display an extinct animal such as a dinosaur, or an unusual or rare animal, even though it does not have a real one. Then the staff must be very inventive. They have to create the animal from artificial materials and produce a perfect-looking copy.

Small insects or microscopic living things can be exhibited in a fascinating way. They can be re-created many times larger than they really are. Larger-than-life

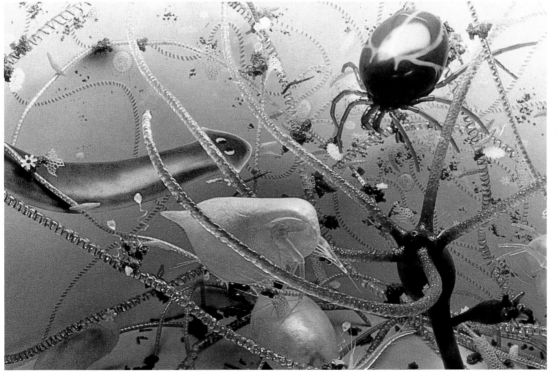

This underwater exhibit made entirely of plastic gives visitors a larger-than-life look at tiny living things in a pond.

displays give visitors an unusually close-up look at tiny plants and animals.

Natural science museums usually do not show plants and animals by themselves. Most are placed in realistic habitat scenes called dioramas. By seeing them in dioramas, people learn more about the natural world they share with plants and other animals.

In the chapters that follow, you will go behind the scenes to see some amazing methods of preparing wildlife for exhibit. Understanding these secrets will make your next visit to a natural science museum even more interesting and fun.

This foam body form will be mounted with the real skin and antlers of a white-tailed deer.

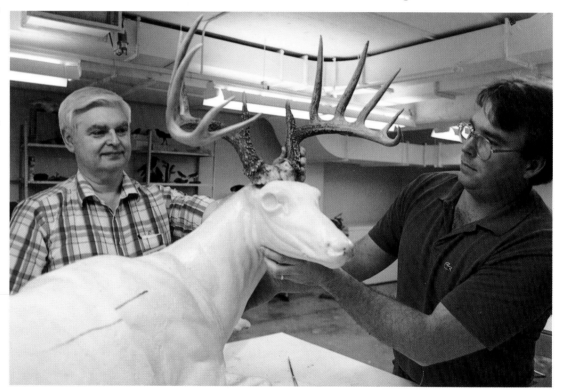

Mounting the King of Beasts

For nearly twenty years, a male African lion lived on a wildlife game ranch. When he died, the lion was donated to the museum for its African diorama.

The huge lion was delivered to the museum's taxidermy studio. Two taxidermists studied the animal's body. They took photographs and measured every part of the lion. These measurements would be very important when the artists made an artificial body. The real skin would fit perfectly when it was mounted onto this carefully made body. (Taxidermists do not stuff animals; they mount skins onto artificial forms. A finished taxidermy specimen is called a mount.)

The taxidermists cut the fur-covered skin straight down the middle of the belly and along the legs. Then they carefully peeled off the skin in one large piece. All the lion's flesh and bones were discarded. The skin was sent to a tannery, where it was cleaned and treated with chemicals to preserve it.

While waiting for the lion's skin to be returned, the artists had work to do. First, they sculpted a clay body, using the measurements taken of the lion. This was a big job that took several days. Details of muscles in the lion's legs and chest were formed in the clay. The huge cat's head was carefully shaped.

Once the clay body was made, the artists were ready for the second step. Because clay is very heavy and not strong enough for a permanent mount, the clay sculpture would not be used as the lion's body form. Instead, it would be used to make a plaster mold from which a sturdy, lightweight cast could be made.

Laying the clay shape on its side, the artists poured wet plaster over it to make one part of the mold. When the plaster hardened, they turned the clay body over and poured plaster onto the other side. Then they repeated this step for the clay underbelly. When all the plaster was dry, the artists had a three-part mold of the

lion's body. Taking the mold apart, the artists removed the clay. It would not be needed again because all of the lion's shape had been perfectly imprinted in plaster.

The artists' next step was to make a tough, lightweight body form to fit inside the lion's furry skin. To do this, they lined each part of the plaster mold with a special paper. The paper was painted with glue that dried overnight. More paper and glue layers were added until the layers were thick and strong enough to support the lion's skin. The sturdy paper shapes were lifted from the three parts of the mold, and the pieces were glued together to make one lion body. When the skin was mounted onto this hollow form, the once 400-pound male lion would look real, but he would weigh only 40 pounds.

The preserved skin came back from the tannery. Two artists coated the entire paper body with glue. This would hold the skin in place as it was mounted. Plastic ear forms were slipped inside the skin to hold the ears up as if the lion were alertly listening. The skin of the lion's head fit neatly around glass eyes, which had already been set in place.

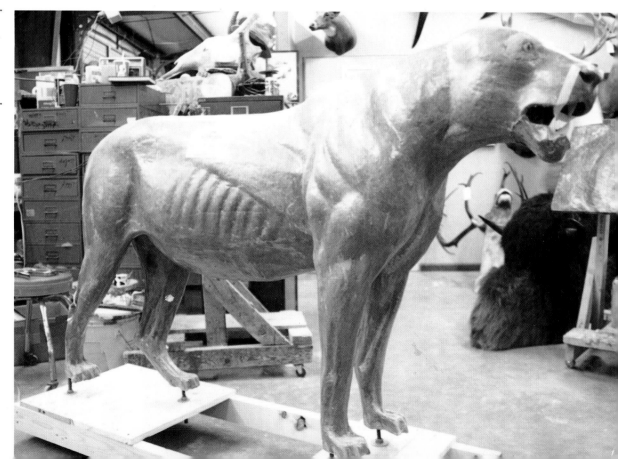

This paper-and-glue body form is strong enough to support the lion's treated skin.

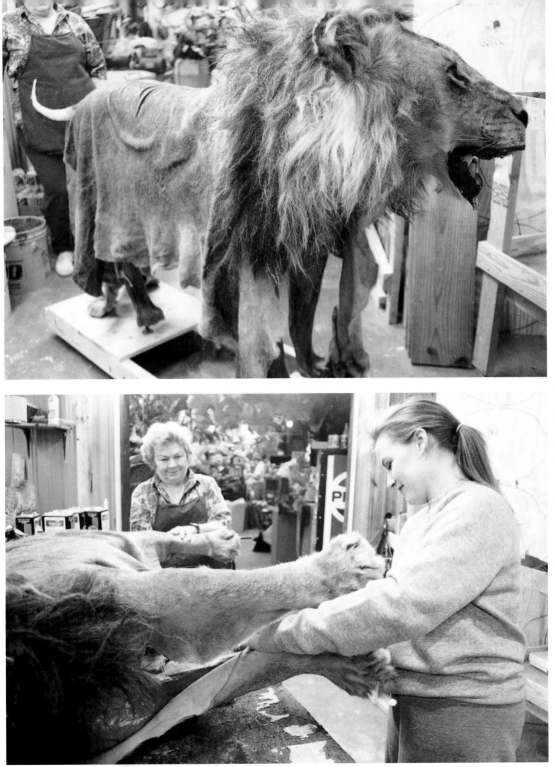

The lion skin is placed on the artificial body.

Artists pull the skin tightly around the sturdy paper form and sew it back together.

Once the skin was stretched over the body, the artists used large needles and strong nylon thread to sew the tough, leathery skin back together. They painted the nose because its color had faded when the skin was treated.

After weeks of preparation, the king of beasts was placed in his new museum home, an African grassland diorama, where visitors would enjoy seeing him for years to come.

The king of beasts seems to roar at museum visitors.

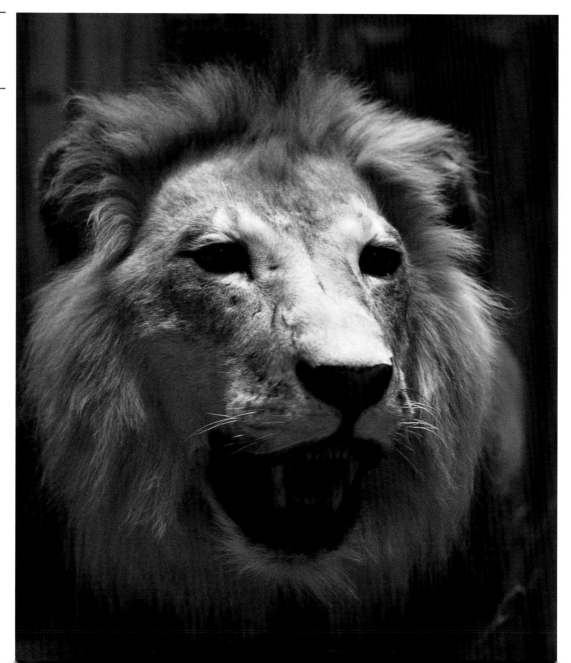

A Brown Pelican Flies Again

The brown pelican is a large and very unusual bird. Its expandable throat can hold more than a gallon of fish and water. Because pelicans fly low over water as they search and dive for food, they are sometimes victims of boating or fishing accidents. A pelican rehabilitation center in Florida treats injured pelicans and nurses many back to health.

One day, the museum received the body of a brown pelican that had died at the Florida center. By mounting and exhibiting the pelican, museum artists would give visitors an opportunity to have a close look at a fascinating bird.

In the workshop, a taxidermist went to work. He cut the feathered skin and carefully peeled it from the body in one piece, as if he were taking off a jacket. Since feathers grow on a bird's skin the way hair grows on human skin, the feathers remained on the skin when it was removed. The beak, wings, legs, and feet were also part of the skin "jacket." The muscles and organs inside the bird were discarded.

The artist washed the webbed feet and treated their tough black skin with a preservative. The feathered skin was cleaned, too. Then a chemical was rubbed on the inside of the skin to keep it soft and leathery. The chemical would keep the skin from rotting.

To replace the bird's insides, the taxidermist made a straw body. He wrapped a bundle of straw tightly with thread until it was the right size and shape for the pelican. He also fastened straw around a long wire to use in the pelican's neck. By bending the wire, the taxidermist would be able to shape the neck and head into a realistic position. Tiny wires were pushed down through the slender legs so they could be moved into position later. The artist slid wires into the wings. These would hold the wings outstretched, as if the pelican were flying. Then the taxidermist

A taxidermist makes a new body for the pelican by wrapping straw tightly with thread.

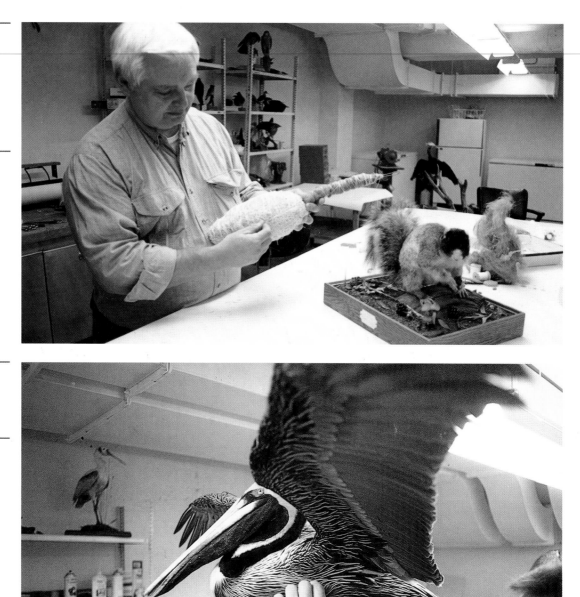

By bending the wire inside, the artist positions the pelican's leg.

14

pulled the skin "jacket" snugly around the straw body form and stitched it together.

From a collection of artificial animal eyes supplied by a wildlife art company, the taxidermist selected pelican eyes made of glass. These eyes had wires that would hold them in the bird's skull. The color of the skin around the pelican's eyes, and of its feet and beak, had faded after the animal died and was treated with preservatives. Using a small brush, the artist touched up the skin with paint to make the bird look real.

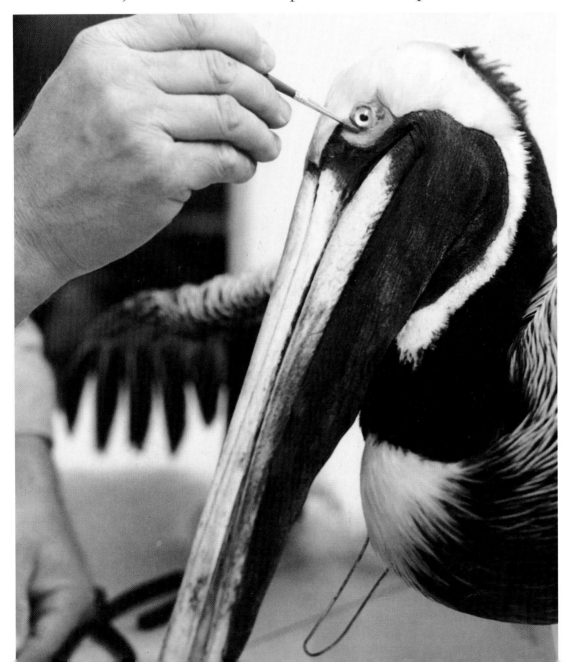

When skin is preserved, its color fades. An artist repaints the bright color around the pelican's eyes.

Although the pelican looked alive, one more step was needed before the big bird could go on exhibit—freeze-drying. The specimen was placed in a freeze-drying machine. Through a special process, the dryer removed any moisture remaining in the mounted bird's skin so the skin would not shrink or wrinkle over time. Animal skins that have not been treated at a tannery are usually freeze-dried.

After several days in the freeze-dryer, the brown pelican was ready to fly once again, but this time safely inside the museum's coastal diorama.

The finished bird is placed in a freeze-dryer for several days. The dryer will remove all moisture remaining in the skin.

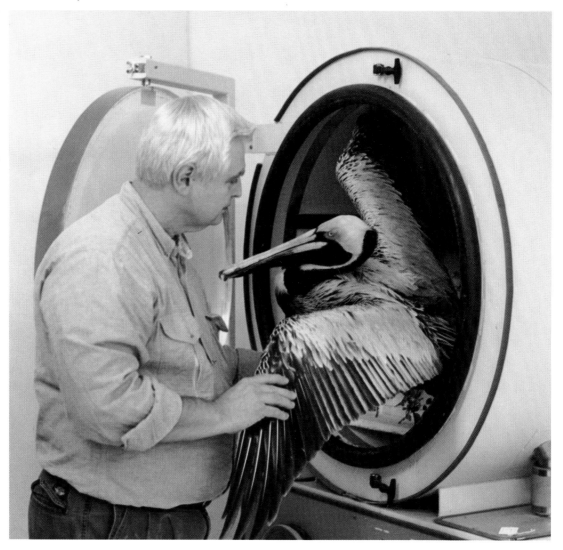

Casting a Rattler

One day the herpetologist, or reptile expert, from a nearby university brought a box to the museum. One of his pygmy rattlesnakes had died, and the herpetologist thought the museum might be able to use it for a wildlife exhibit.

The museum artist placed the snake in the freezer until she had time to work on the beautiful two-foot-long specimen. She would make a mold of the actual snake, then a realistic, accurately painted cast. The process would require several days.

When the artist began work, she thawed the frozen rattlesnake and curved its body into a lifelike position. She poured thick liquid plaster over the rattler. The

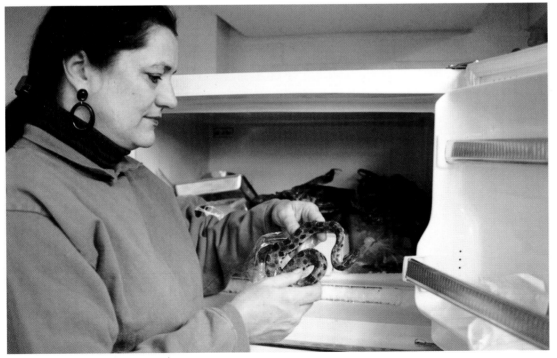

The reptile molding and casting expert thaws the real pygmy rattler that she will use to make a plaster mold.

A two-part mold of the rattlesnake allows the artist to cast the entire body, top and bottom.

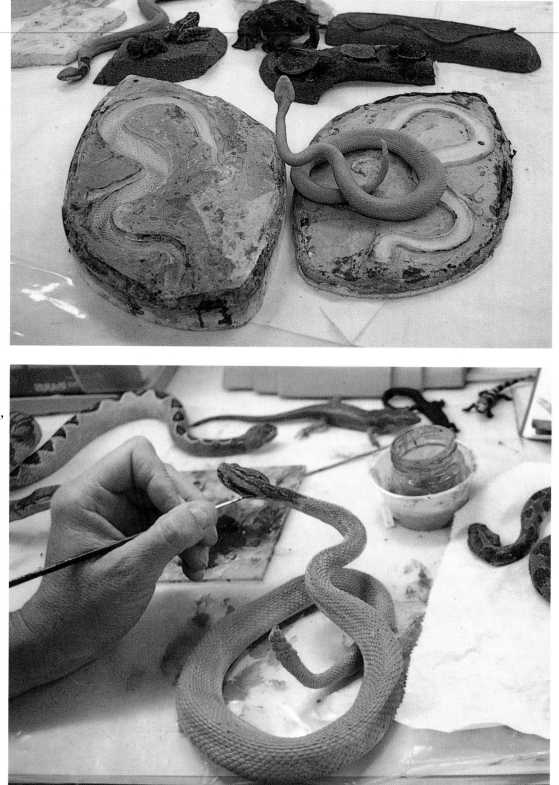

Using the real snake and some color photographs, the artist paints the rubber cast as accurately as possible.

18

plaster hardened and made a mold of the snake's back and sides. Then the artist turned the snake upside down and poured plaster over its belly. This completed a two-part plaster mold. The snake's scales, top and bottom, were clearly imprinted in the hardened plaster. The real snake was returned to the freezer so it would not decay. The snake would be needed again when the artist was ready to paint the cast.

To make a cast, the artist fastened the two-part mold tightly together and poured liquid rubber through a small opening. In a few hours, the rubber hardened. The artist took the mold apart and removed a rubber snake. The cast was firm but flexible. The new rattlesnake looked exactly like the real pygmy rattler, but it had none of the snake's distinctive markings. Using a hair dryer to warm and soften the rubber cast, the artist twisted the cast into a coiled position and let it cool.

Next came the step that would make the cast look real—painting. The artist took the dead rattler from the freezer so she could match its colors and patterns. Painting such tiny detail on the scales took several days. But when she finished, the pygmy rattlesnake looked as though it could slither away.

Museums often make plaster molds of snakes, lizards, small alligators, frogs, toads, and salamanders. These reptiles and amphibians have thin and tender skin. Because this type of skin cannot be preserved very easily, these animals are not usually mounted. Molds of them, however, can be used over and over again to make many casts.

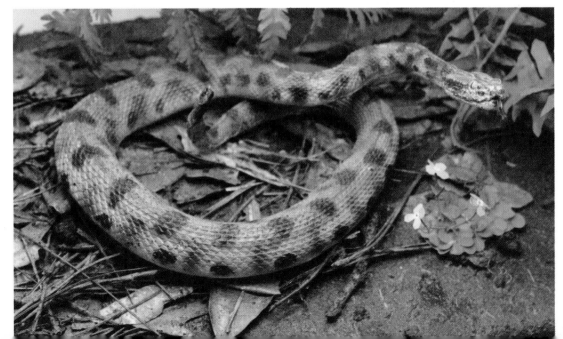

The museum's education department has requested a pygmy rattlesnake for a program about venomous animals.

A Six-Foot-Long Praying Mantis

Museums often make exhibits on a giant scale to give visitors a close look at small things without using a magnifying glass. Some ideas come from visitors themselves.

One day a boy brought in a live insect in a terrarium. He asked the museum naturalist what the insect was. The naturalist explained that it was a praying mantis, a fascinating little creature that captures other insects for its food. He suggested that a praying mantis would make an interesting exhibit. The boy left the insect at the museum so the staff could think of a way to create an exhibit. The problem was that the insect would be hard to see because it was only three inches long.

The staff decided to make a larger-than-life model. The museum's mantis would be six feet long!

The artist studies the live praying mantis before creating a six-foot-long model.

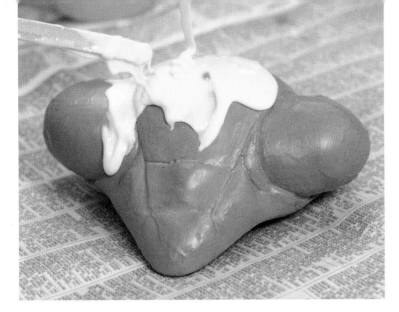

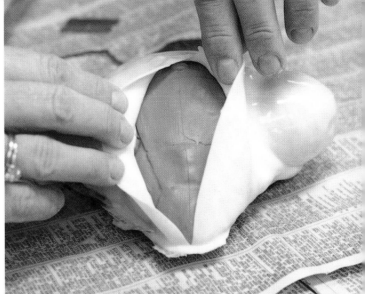

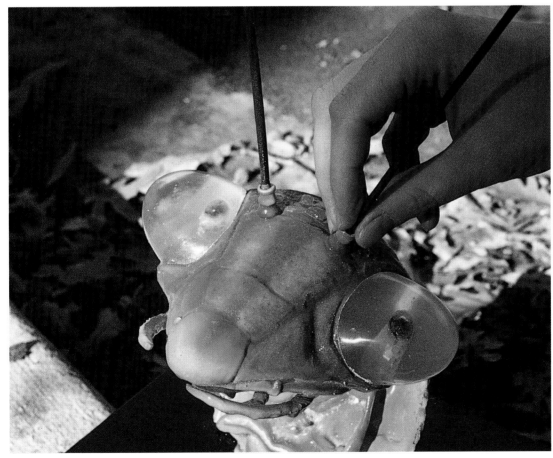

After sculpting a giant mantis head out of clay, the artist makes a mold by pouring thick liquid rubber over it (above left). When the rubber dries, the flexible mold is carefully cut and removed (above right). It will be filled with liquid plastic, which dries clear and hard, for the final cast. "Antennae" made of carved wood are attached after the cast is painted (left).

An artist went to work. He studied the slender mantis, making photographs and drawings before releasing the insect. Referring to his photos and illustrations, he made a clay sculpture of a mantis head, twenty-five times larger than the real one. After he finished the clay head, the artist covered it with liquid rubber. When the rubber dried, it made a flexible mold. The artist cut and peeled the stretchy mold from the clay head. Using the mold, he made a cast of the head for a six-foot-long praying mantis.

Next, the artist carved the mantis's body and legs from lightweight foam. Thin metal rods were pushed into each leg so the artist could bend them into a realistic position. He cut the mantis's wings from a sheet of thin plastic. By squeezing tile cement mixed with glue from a tube, like toothpaste, the artist made wing veins.

He then attached the head, wings, and legs to the body with wire. He coated the

The wing veins, made by squeezing tile cement mixed with glue from a tube, show clearly after the final painting.

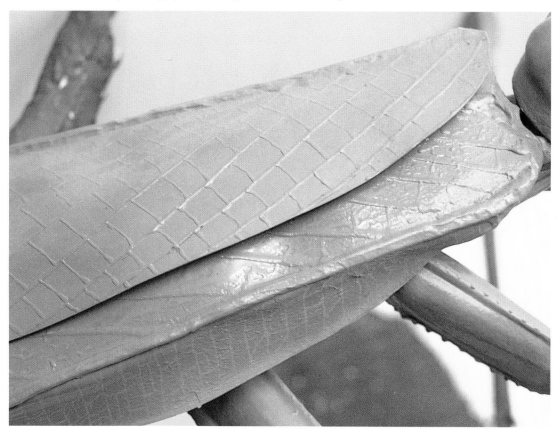

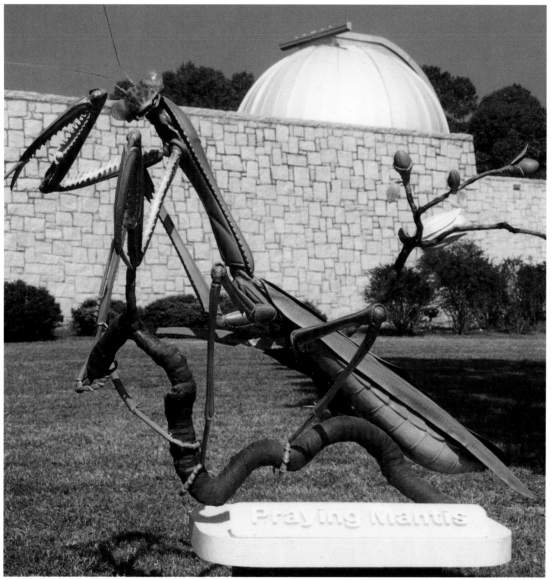

whole six-foot insect with glue that dried clear. The glue coating would be a good surface for painting, and it would help hold the creature together. Finally, the artist painted the giant mantis green to match the real insect.

After weeks of work, the larger-than-life praying mantis was finished and ready to display.

23

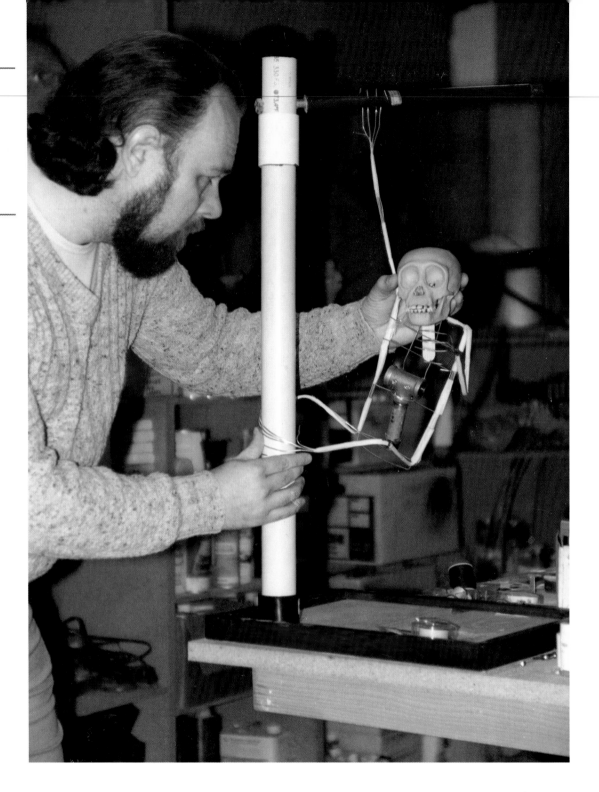

The artist uses metal rods to make a framework for the baby orangutan and fits it with the artificial skull.

A Baby Orangutan for the Rain Forest

Rain forests are some of the most endangered habitats on earth. Few people get a chance to visit one, so the museum staff decided to build a rain forest diorama. To re-create a Sumatran jungle, they wanted a baby orangutan.

At one time, more than five hundred thousand orangutans lived in rain forests all over Asia. Now only a few thousand of them survive in the jungles of Borneo and Sumatra. Because this mammal is so rare, the museum had no way of acquiring a specimen for taxidermy. Instead, the exhibit staff hired a special kind of wildlife artist, one who creates realistic animals using only artificial materials.

After studying books and pictures, the artist began making a baby orangutan that would look so alive, no one would believe it wasn't real. First, he needed an artificial orangutan skull. Fortunately, he was able to buy one from a science supply catalog. Then he bent and twisted wires into a "skeleton" the size and shape he wanted for the baby orangutan. The artist extended one wire arm so the baby would look as though it were holding on to a limb.

The entire framework, including the skull, was covered with clay. The artist carefully sculpted the clay into the shape and size of a three-month-old orangutan. He smoothed clay over the skull to form the head and face as perfectly as he could.

Next, the artist made a two-part plaster mold of the clay body in the same way the taxidermists had made the three-part lion mold. He removed the plaster mold from the clay orangutan and was pleased that the details of the youngster's body were so clearly imprinted.

He painted a thin layer of liquid rubber in each part of the mold and then clamped the two parts together. Next, the artist squirted a thick, foamy liquid through a small opening in the mold. The foam would swell up and fill the mold

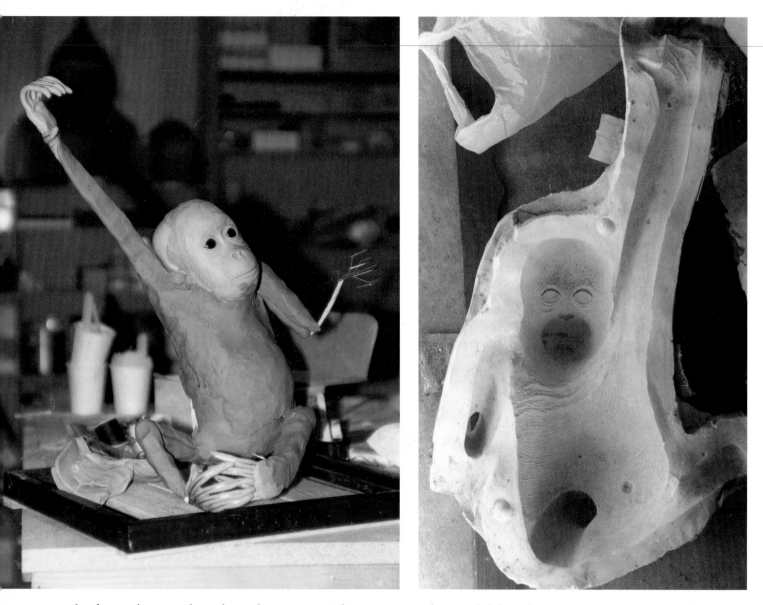

before drying hard and strong. This material would be the orangutan's new body.

The next day, the artist removed the foam body from the mold. It looked like a colorless and hairless baby orangutan. The thin coat of rubber that had been painted inside the mold was the baby's "skin." This rubber skin felt soft and real. The artist next painted the skin light brown.

Young orangutans do not have fur coats, but they do have some hair. The

26

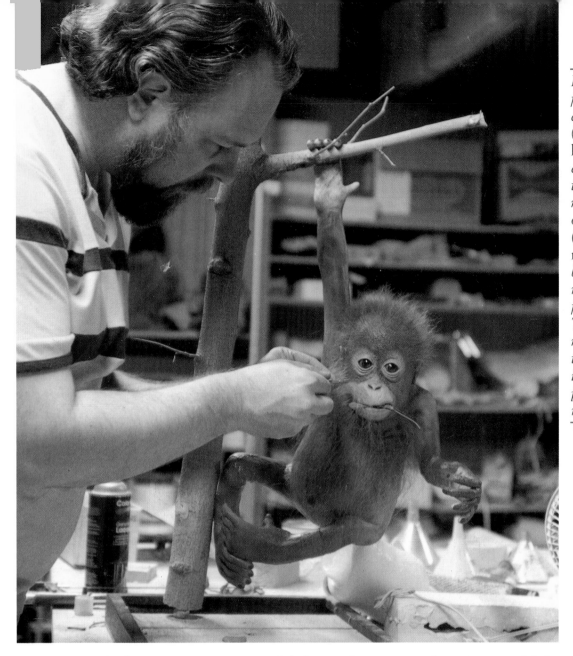

First the framework is covered with clay (opposite page, left). Next, the clay shape is used to make a plaster mold of the orangutan's body (opposite page, right). A foam body coated with rubber is made from the mold. Then each hair, made of wool thread, is individually punched into the rubber skin (left).

museum's baby orangutan would have hair, too, but it would be artificial. Each artificial hair was made of wool threads. The artist punched each thread into the skin with a needle. This was tedious work but very important, because hair made the baby orangutan look real. Glass orangutan eyes were not available from a wildlife art company, so lifelike eyes were sculpted and painted by the artist.

The little orangutan was placed in a tree, grasping a branch. Although the tree

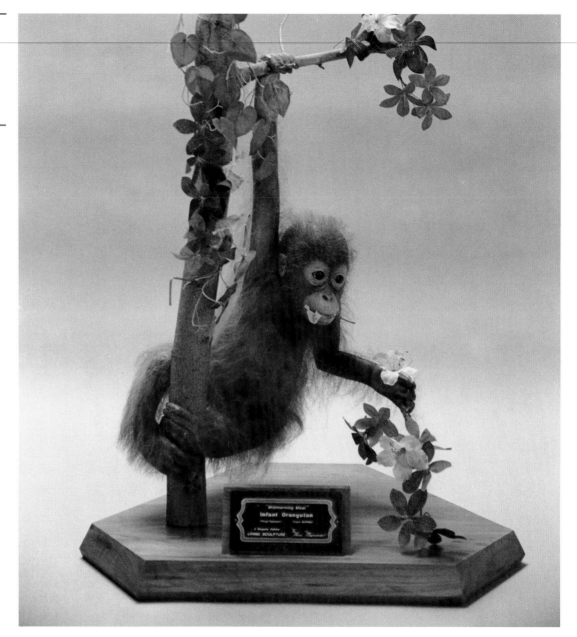

Clinging to a branch, the baby orangutan looks very much alive as it munches on a flower.

was artificial, its leaves and flowers looked exactly like those on a tree of the Sumatran rain forest. The baby orangutan looked as if it could climb right out of the museum's rain forest exhibit!

Bringing Back a Prehistoric Dimetrodon

Dinosaurs are favorite museum exhibits. These fascinating animals, extinct for more than 60 million years, stir the imaginations of visitors of all ages. Fossils are the only clues scientists have to the mystery of dinosaurs. Sometimes enough fossils of one kind of dinosaur are found to allow scientists to reconstruct a complete skeleton. Studying a fossil skeleton gives everyone an idea of the shape and size of a dinosaur.

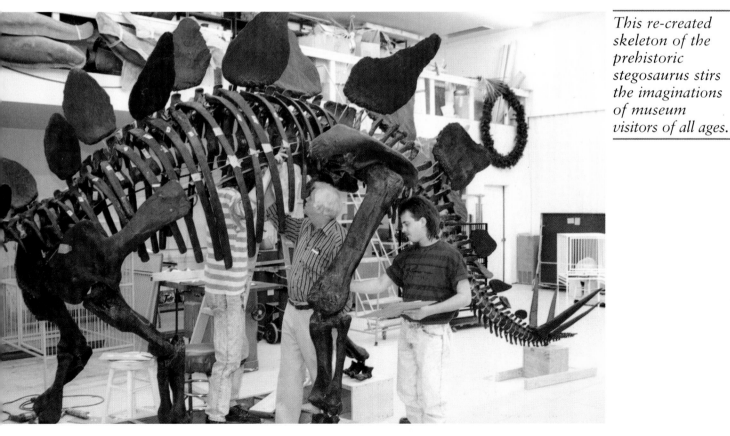

This re-created skeleton of the prehistoric stegosaurus stirs the imaginations of museum visitors of all ages.

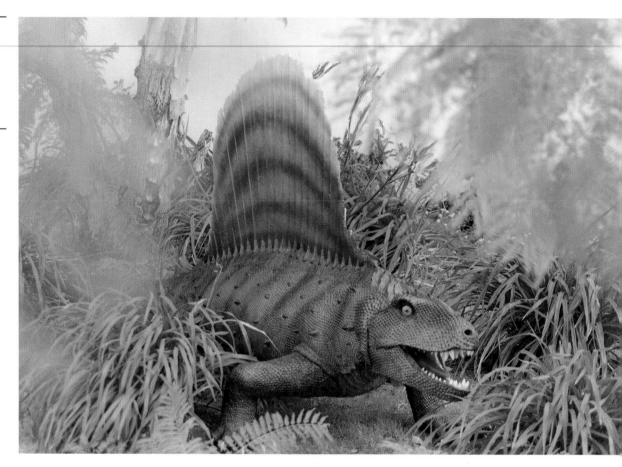

But dinosaurs are not the only fascinating prehistoric animals. In fact, some very unusual creatures lived before them. One such creature is the dimetrodon. Scientists believe that the dimetrodon was a reptilelike animal that lived 280 million years ago. This was millions of years before dinosaurs! The ten-foot-long predator had sharp teeth and a spectacular sail on its back.

The museum staff decided to create an exhibit about the Permian period, the time when dimetrodons roamed the earth. The specialist who made the realistic baby orangutan was given the challenge of re-creating a dimetrodon for the prehistoric exhibit.

The artist learned as much as possible about dimetrodons before he started to work. He studied photographs of a fossil dimetrodon skeleton as well as a few

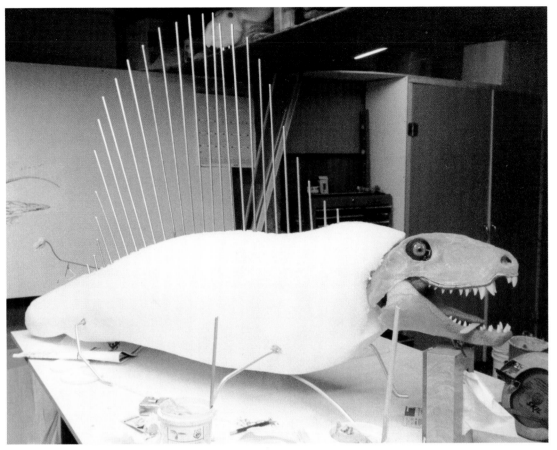

Carved foam is placed over a metal structure to create the body of the dimetrodon.

illustrations of how scientists believe the animal might have looked.

The artist made a "skeleton" of aluminum rods. Rods were also used to make the spines of the animal's sail. Next, the artist purchased a replica dimetrodon skull from a science supply company. He made a plaster mold of the skull and then used the mold to make a lightweight acrylic cast. Acrylic is a thick liquid that hardens like plastic in a few hours. After attaching the acrylic cast of the skull firmly to the neck rod, the artist carved a foam body. He fastened it to the metal framework.

Once the body form was complete, the artist added the details that made the animal look alive. He made molds and then acrylic casts of every tooth in the skull he had purchased. These teeth were glued into the jaw. The artist dyed some of the liquid acrylic pink and poured it around the teeth. When it hardened, the acrylic

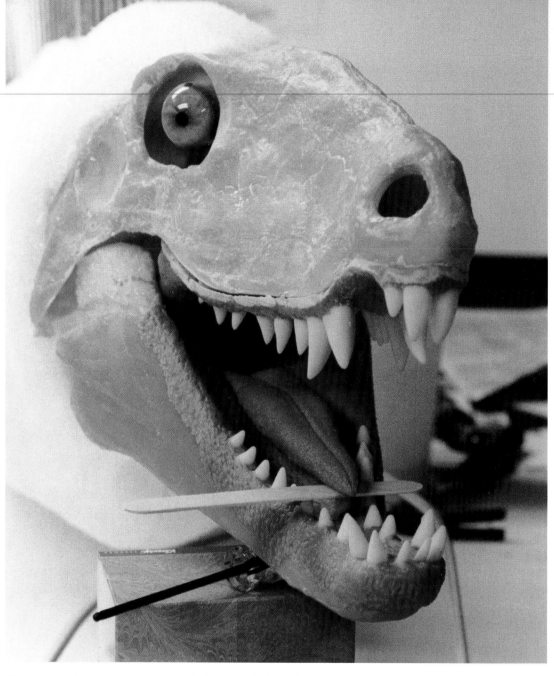

looked like the dimetrodon's gums and helped hold the teeth in place. The artist made a plastic tongue and wired glass eyes into the head.

Turning the body onto its side, the artist poured a thin coat of resin over the rods in the sail. Resin is a liquid that dries even harder and stronger than acrylic.

The artist puzzled over how the giant lizardlike dimetrodon's skin may have

32

The Permian predator's spectacular sail is made of resin poured over metal rods.

looked and how he could reproduce it. A friend told him that a huge lizard called a Komodo dragon had been mounted many years ago and was stored at a nearby nature center. This gave the artist an idea. He got permission to make a few small molds of the Komodo dragon's skin. He was careful not to damage the preserved skin of the sixty-year-old mount.

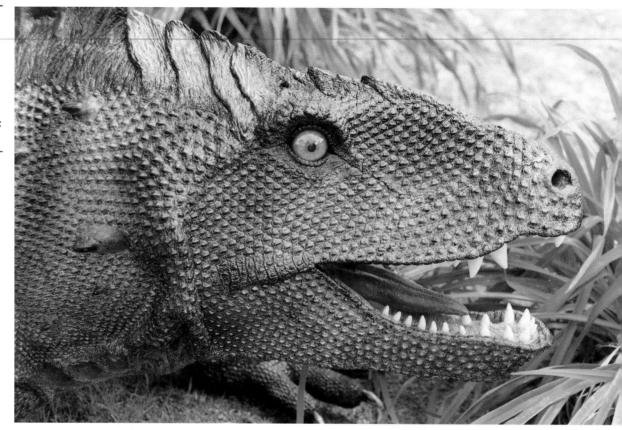

The lizardlike skin of the dimetrodon is made of rubber that was poured into molds of a Komodo dragon's skin.

The artist poured liquid rubber into the skin molds made from the Komodo dragon. He did this over and over again until he had enough pieces to cover the dimetrodon. Once the rubber skin was in place, the artist had to decide what color to paint it. Since no one knows what color this extinct animal was, the painting was a combination of art and scientific imagination. When the dimetrodon was placed in the Permian exhibit, the entire prehistoric scene seemed to come to life.

Dioramas: Natural Settings for Museum Wildlife

Preparing a diorama for displaying museum wildlife can be just as challenging as preparing the animals themselves. In order for the scene to look real, it must be accurate. The plants have to be those that would live with the animals on display. If

Dioramas give museum visitors an opportunity to see animals in natural settings.

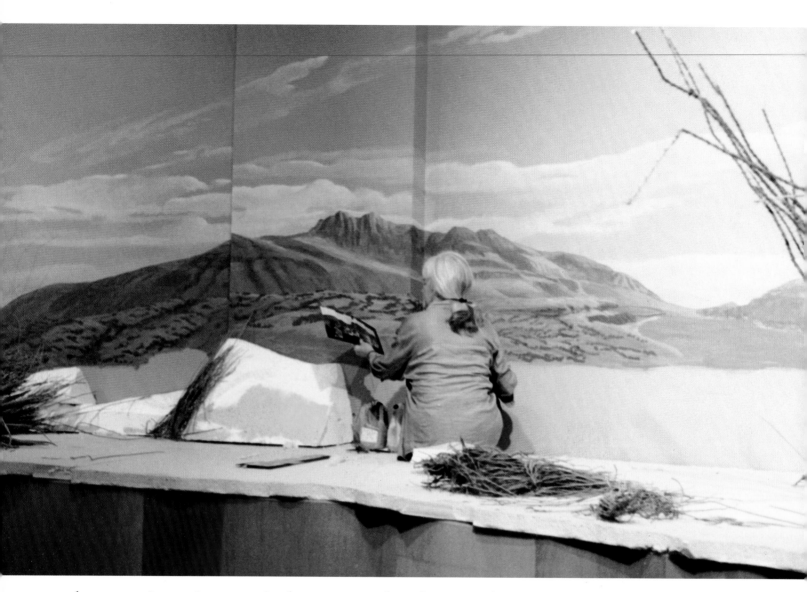

the scene is set in a particular season, the plants and animals should look like they would at that time of year. And the background mural an artist paints for the scene must be true to life, too. Only by working closely with scientists and experts in natural history can the artists create the final diorama.

It might seem easy to bring trees, leaves, rocks, small plants, and soil indoors and build an exact copy of an outdoor scene. But in a museum, all materials must

While painting a background mural for a diorama, an artist studies a photograph of an Arizona desert (left). *Cutting, painting, and fastening dozens of artificial leaves for a single tree branch is tedious work, but real leaves would not last long in an exhibit* (right).

be fireproof, insect-proof, and very long lasting. Green leaves and flowers would not live very long in an exhibit. Only artificial ones will look alive for many years. Making the fakes look exactly like the real ones is a big job. Silk leaves must be individually attached to wires and placed on specially made tree branches. If realistic silk leaves and flowers cannot be purchased, the artist will form them from thin sheets of plastic and then hand-paint each one.

Habitat dioramas make it possible to display scenes people rarely, or never, see. They might take you underwater, underground, or even back in time! An underwater scene is not hard to make. Instead of water, the artist uses a sheet of thin clear plastic for the water's surface. Then a special clear liquid called resin is poured on top of the sheet. Even when the resin is dry, it looks wet. Artificial plants, insects, and other animals are placed beneath the plastic surface and look as though they are underwater.

The artists who create dioramas and produce lifelike models and taxidermy specimens know that animals are important and beautiful. Their art helps museum visitors understand and appreciate nature. The artists know they have succeeded when they hear visitors ask, "Are those animals *real*?"

Circles formed in the resin just before it hardened add a realistic touch to this pond diorama.

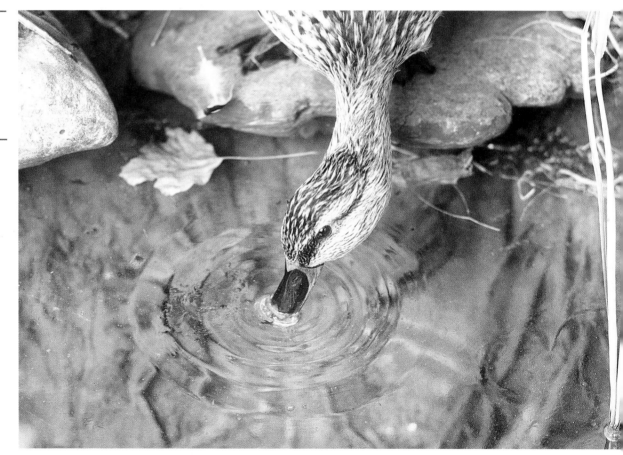

Glossary

Artificial	not natural; something made by humans.
Cast	a copy of an animal's body made from a mold.
Dimetrodon	a reptilelike animal that lived long before dinosaurs.
Diorama	an exhibit that shows plants and animals in their natural homes; also called a habitat display.
Exhibit	a museum display.
Herpetologist	a person who studies reptiles.
Mold	an impression in plaster or other material; molds are used to make casts.
Plaster	a powder that is mixed with water to form a thick liquid for mold making.
Prehistoric	the time before written history.
Preservative	a substance used to treat animal skins so they will last a long time.
Specimen	an animal the museum uses in preparing an exhibit.
Tannery	a place where the skin of a large mammal is treated in preparation for mounting.
Taxidermy	the art of mounting preserved skins of animals onto artificial body forms.

Index